THE URBAN SKETCHING HANDBOOK

PEOPLE AND MOTION

© 2014 by Quarry Books
Text © 2014 Gabriel Campanario
Illustrations © Individual artists
Nonattributed illustrations © Gabriel Campanario

First published in the United States of America in 2014 by
Quarry Books, a member of Quarto Publishing Group USA Inc.
100 Cummings Center
Suite 406-L
Beverly, Massachusetts 01915-6101
Telephone: (978) 282-9590
Fax: (978) 283-2742
www.quarrybooks.com
Visit www.Craftside.Typepad.com for a behind-the-scenes
peek at our crafty world!

10 9 8 7 6 5 4 3 2

ISBN: 978-1-59253-962-8

Digital edition published in 2014
eISBN: 978-1-62788-206-4

Library of Congress Cataloging-in-Publication Data available

Design: www.studioink.co.uk
Cover image: front cover & right, Gabriel Campanario
Back cover: Cathy Gatland

Printed in China

THE URBAN SKETCHING HANDBOOK

PEOPLE AND MOTION
Tips and Techniques for Drawing on Location

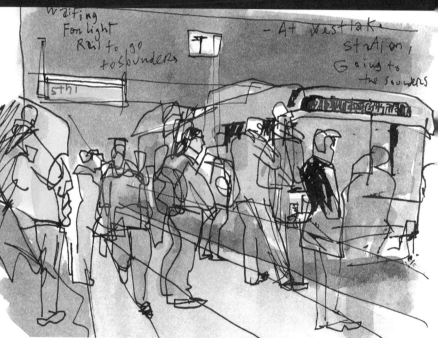

**GABRIEL
CAMPANARIO**

Quarry Books
100 Cummings Center, Suite 406L
Beverly, MA 01915

quarrybooks.com • craftside.typepad.com

About This Series

As hobbies go, urban sketching is simple and accessible. All you need to do is grab some drawing tools and capture what's happening in your city or neighborhood.

Once you get out and about, pen or pencil in hand, you'll discover the many different layers and angles to urban sketching: How can I draw people when they move around so much? Do I have to sketch every brick? What should I do with my sketches when I'm done?

Whether you are a seasoned sketcher or just starting out, *The Urban Sketching Handbook* lays out key strategies and examples that will come in handy next time you open your sketchbook.

Sketchbook

Fountain pen

Pencil

Ballpoint pen

Watercolors

Waterbrush

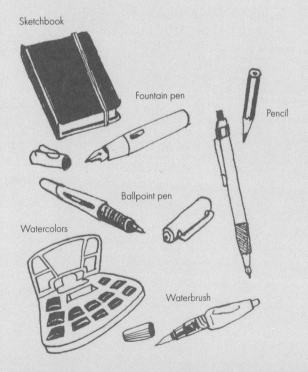

CONTENTS

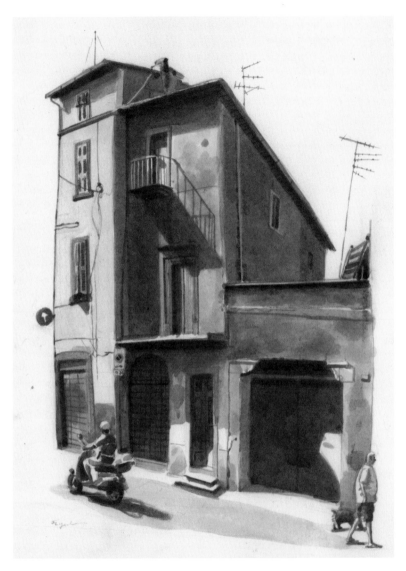

♠ When you get a handle on incorporating people into your scenes, your sketches will become true reflections of a moment in time, such as when that guy with the Vespa zoomed by or a neighbor stepped out to walk the dog.

FRED LYNCH

Italian Street

6.5" x 9.4" | 16.5 x 24 cm; Newton brown ink on Arches hot pressed watercolor block paper; 2 hours onsite, plus spots of dark ink added in the studio.

INTRODUCTION

Human activity defines a city just as much or more than the buildings that appear in the postcards. Can you imagine a sketch of New York's Times Square without the bustling crowds; Venice with no gondoliers; or Seattle's Pike Place Market without the guys tossing fish?

As an urban sketcher, you may choose to ignore all the human noise. A city skyline or a lonesome historic building will still make for great, timeless sketches. But the rewards of sketching people are too great to always leave them out of the picture.

If you love to relax at the coffee shop and do some people watching, you'll also understand what makes sketching people so much fun. From the fashion and the hairdos, to the faces or the way people walk, each person has an individual expression the urban sketcher delights in capturing.

Sketching people, however, can be very frustrating. No complex engine or object of any kind can be as hard to draw as a human being. We are very sophisticated machines, full of joints and muscles that perform myriad gestures and facial expressions. Running, jumping, pounding with a hammer—think of the activities our bodies are able to do!

But don't let me discourage you. A strong grasp of anatomy and keen observational skills will get you drawing people sooner rather than later. Start with mastering proportions. Get the hang of contour sketching and gestural drawing. Focus on expression. Add context.

And beyond the technical mastery of the craft, consider this to get you in the spirit of people urban sketching: Drawing people is a great way to learn more about your community. A stranger may be reluctant to be photographed, but I've yet to find someone who'd shy away from being immortalized in pen and paper.

Get to know your subjects. Learn their first and last names. Ask the market vendor where his fruit comes from. Or compliment—and tip—the busker for the song he played while you drew him.

People are the life of a city. To draw them is to get to know the place.

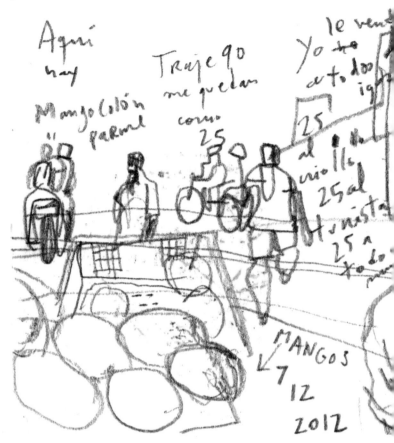

🎧 Some opportunities to draw people happen spontaneously. As I was sketching in the Dominican Republic a couple of years ago, a street vendor selling mangoes took interest in my work, which led to this drawing.

Mango street vendor

6.6″ x 3.6″ | 16.8 x 9.2 cm; Staedtler Mars mechanical pencil with 2 mm HB graphite lead pencil; 15 minutes.

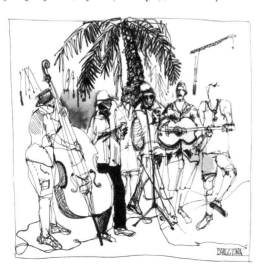

⊂ People are part of the pulse of the city. Buskers in particular may be some of the most willing subjects for an urban sketcher to capture, as their goal is to draw as much attention as possible.

JESICA LEWIT

Músicos en las calles de Barcelona

8" x 8" | 20 x 20 cm; Fountain and dip pens, ink and watercolor on paper; 30 minutes.

SKETCH HERE!

KEY 1
PROPORTION

Here's something that makes drawing people easier than you think: Humans are very proportionate. We come in all shapes and sizes—short and tall, skinny and wide—but we still follow a standard template: Our height equals about 7.5 or 8 times the height of our head. The bottom of the pelvis marks the body's half point.

When you get the basics of human proportion down, you are well equipped to include people in your urban sketches any time. In other words, once you can draw one proportionate person, you can draw them all. On the contrary, make the head of a person too big or an arm too long and you'll be making sketches of aliens, or caricatures, instead of believable drawings.

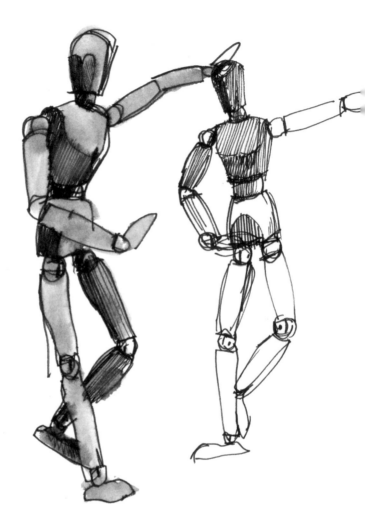

Master the stick figure sketch.

Don't underestimate the power of the stick figure! Practice drawing them from imagination to cement your grasp of how humans sit, jump, and run.

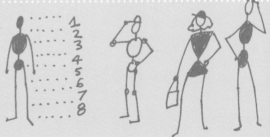

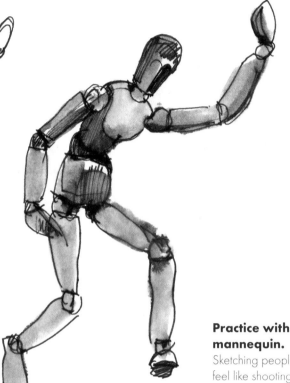

☾ Sketching a wooden mannequin helps you think of limbs and body parts as a series of cylindrical shapes connected by circular joints.

Practice with a wooden mannequin.

Sketching people out and about can feel like shooting a moving target, at first. Start with some home practice. Use these bare-bones wooden contraptions to get a grasp of the proportion and mechanics of the human body. They are available at most art supply stores.

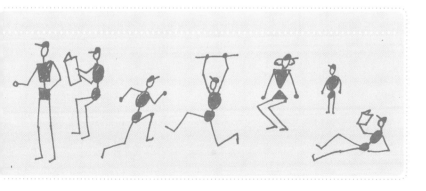

Practice drawing people you know.

Taking figure drawing lessons will undoubtedly help you develop your understanding of human anatomy and proportion, but don't overlook the opportunities to sketch the many willing models who surround us every day. My family, sketcher friends, and even some coworkers often appear in my sketchbooks.

➲ Fellow urban sketchers make great models.

7" x 5.5" | 18 x 14 cm; Pilot G-Tec on Moleskine sketchbook; 20 minutes.

⊍ Office meetings offer a good opportunity to draw people; just make sure your boss doesn't catch you.

4.2" x 4" | 11 x 10 cm; Fountain pen and watercolors on ruled notebook; 2 minutes per portrait; colored later.

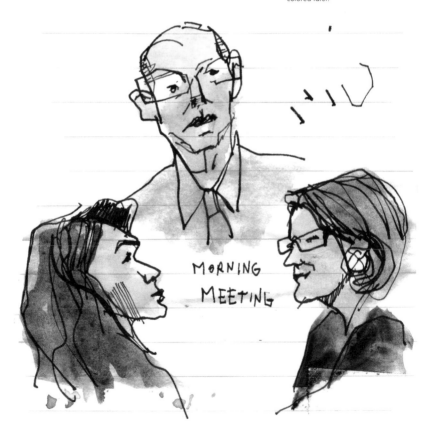

MORNING
MEETING

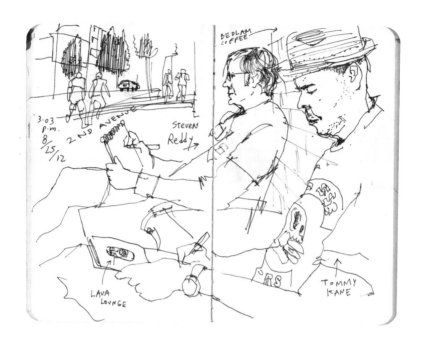

BEDLAM COFFEE

3.03 p.m. 8/25/12

2ND AVENUE

STEVEN Reddy →

TOMMY KANE

LAVA LOUNGE

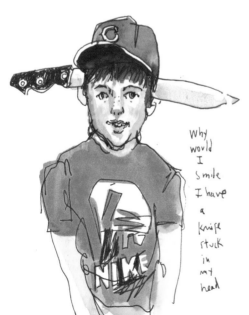

Why would I smile I have a knife stuck in my head

Drawing kids

My son was trying out a gag prop at the toy store, so I took a few minutes to draw him. Notice that when you draw kids, facial features are very soft, so go easy on the linework. Their heads are also bigger in relation to their body. There's nothing like a quick sketch to immortalize memorable family moments.

4" x 6" | 10 x 15 cm; Uni-Ball Vision pen and watercolor on Stillman & Birn Gamma Series sketchbook; linework: 2 minutes; colored later.

Study head proportions.

Heads and faces are fascinating subjects. Whether you are sketching during your commute or at the coffee shop, interesting faces will crop up and you'll want to draw them. Though each face is unique, certain proportions apply across the board. I've studied Gary Faigin's *The Artist's Complete Guide to Facial Expression* to improve my skills in this area.

↻ Profile of bus commuter
3.5" x 3.5" | 9 x 9 cm; G-Tec Pilot pen on Moleskine sketchbook; 10 minutes.

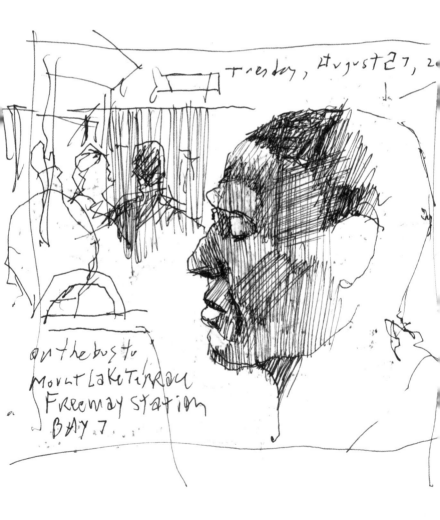

Think bones.

The face can be divided into three zones: chin to bottom of the nose (1); bottom of the nose to eyebrows (2); and eyebrows to top of forehead (3). A head's middle point (4) lies right below the eyeballs.

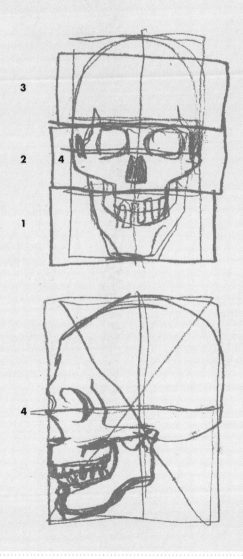

∩ ADEBANJI ALADE

London commuters

12" x 6" | 30.5 x 15 cm; Black Bic Ballpoint pen and N75 Tombow dual wash felt marker on Seawhite of Brighton Sketchbook; about 20 minutes.

Look for urban models.

Public transportation offers a great setting to put your people drawing skills to the test. Start with commuters who are unlikely to notice you—those who are reading or dozing off after a hard day's work.

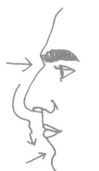

Workshop

→ Draw heads during a work meeting or lecture.

→ Draw heads during your commute.

→ Draw a family member while they are doing something: reading, doing chores, or just watching TV.

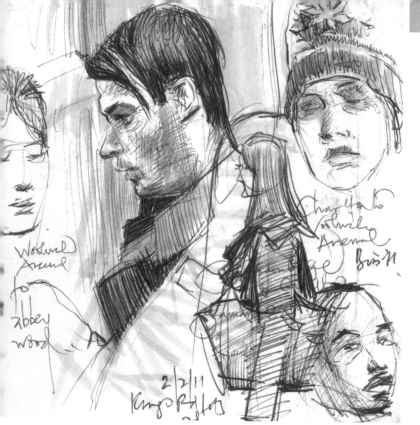

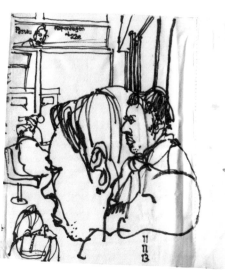

Draw profiles.

Study the head's bone structure when you sketch people in profile. Pay special attention to the peaks and valleys of facial topography: the points of connection between forehead and nose, nose and lips, and lips and chin.

↶ **ROLF SCHROETER**

Zentraler Omnibusbahnhof

8" × 8" | 20 x 20 cm; Pentel Brush pen on 30 gsm light Chinese calligraphy paper; about 15 minutes.

SKETCH HERE!

KEY II
CONTOUR

One can never stop studying human anatomy to get better at drawing people. But while you continue brushing up on books on the subject, sketching family, friends, and sleepy commuters, let's go over a sketching method to draw people that doesn't require any previous understanding of proportions or body mechanics. I'm talking about contour drawing.

People contours are easier to draw than fully fleshed individuals. I love the tactile nature of contour drawing: Imagine the tip of your pen actually touching the edges of the shapes you are outlining. And because these outlines can be done fast, often without looking at the paper, they are ideal for on-the-go urban sketching.

Make blind contours.

A blind contour means you keep your eye on the subject and draw without looking at the paper. You have to imagine that the tip of your pen is touching the edges of what you see. Obviously, you can look at the paper every now and then to make adjustments. That's known as a *semiblind contour*, and it is the method I used to make these sketches.

◑ Commuter reading book

5" x 7" | 13 x 18 cm; Pilot G-Tec 0.3 on Moleskine sketchbook; about 2 minutes.

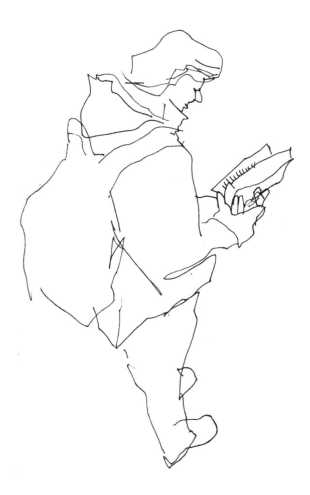

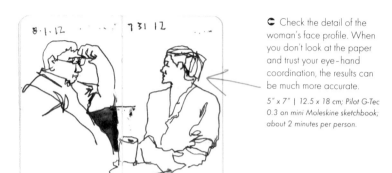

⟳ Check the detail of the woman's face profile. When you don't look at the paper and trust your eye-hand coordination, the results can be much more accurate.

5" x 7" | 12.5 x 18 cm; Pilot G-Tec 0.3 on mini Moleskine sketchbook; about 2 minutes per person.

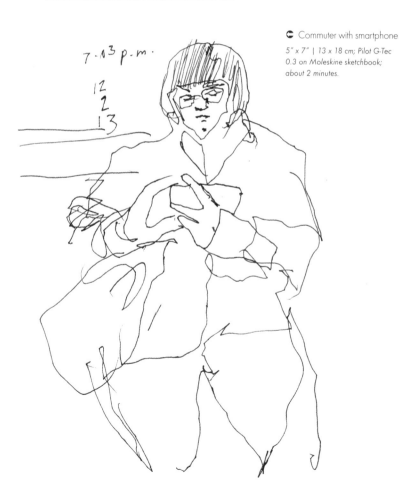

⟳ Commuter with smartphone

5" x 7" | 13 x 18 cm; Pilot G-Tec 0.3 on Moleskine sketchbook; about 2 minutes.

Make "people skylines."

Contours are especially effective to draw groups of people, as shown in these sketches by Thai sketcher Asnee Tasna. I like to think of these as "people skylines."

⮎ When you overlap contour lines, you create the illusion of transparency, which can also suggest movement. Nothing stands still like the hands of these people having a meal.

CAROL HSIUNG
Perfect Day for Pho
6" x 4" | 15 x 10 cm; Micron 01 black pen; 10 to 15 minutes.

↺ **ASNEE TASNA**
Bangkok choir rehearsal
11" x 5" | 28 x 13 cm; 0.2 pigment ink pen and graphite on plain paper; 15 minutes.

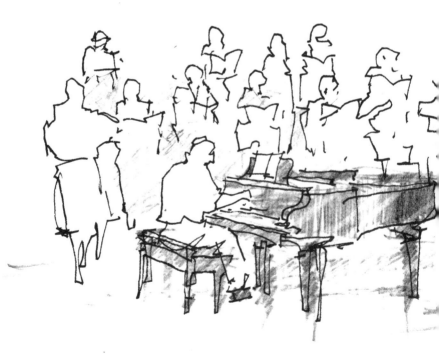

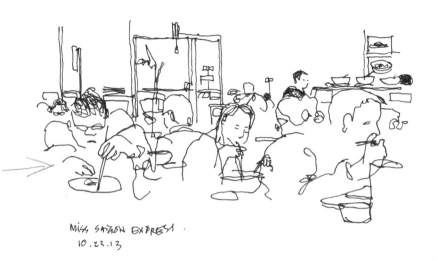

MISS SAIGON EXPRESS ·
10.23.13

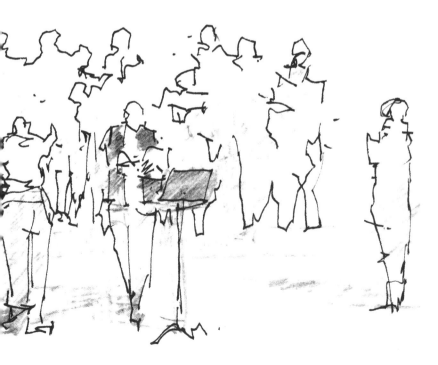

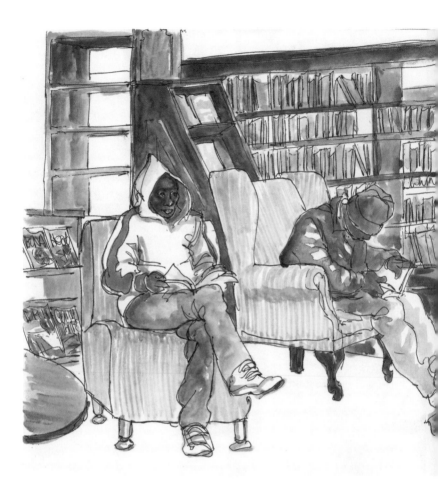

Fill in the shapes.

Contours don't mean your sketches have to look like wire sculptures. Most of the fun of sketching is in adding shade and color to those contours.

○ This sketch may not appear to be a contour drawing, but examine it closely and you'll identify the outlines of people, chairs, and shelves.

CATHY GATLAND

Johannesburg City Library

15" x 7.6" | 38 x 19 cm; Pen and watercolor on sketchbook; about 45 minutes.

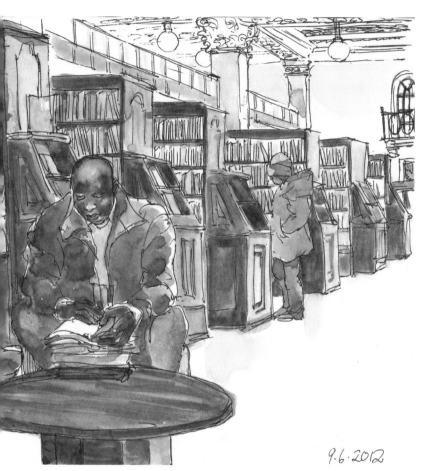

9.6.2012

○ KALINA WILSON

Commuter shoes

4" x 5.5" | 10 x 14 cm; Reform
1745 fountain pen with Noodler's
#41 Brown ink and a Faber-Castell
PITT artist pen in Dark Naples
Ochre on Canson ArtBook
Universal sketchbook; about
5 minutes per sketch.

Workshop

Practice contour
sketching while using
public transportation.
Remember to keep your
eyes on the target, not
on the paper.

SKETCH HERE!

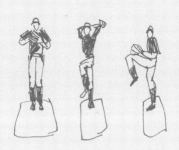

KEY III
GESTURE

It's one thing to draw semistatic commuters or readers, but what about immortalizing their gestures as they move?

Instinct may tell you that to draw things that move quickly, you have to draw fast. But the key is not so much to draw fast, but to look very attentively and know when to put pen to paper. If you busy yourself making marks but don't observe enough, you'll be missing important visual cues to make the sketch work.

Memory matters. Focus first on paying attention and absorbing as much visual information as possible, then on drawing what you see. This approach will allow you to identify patterns of motion and isolate the gestures you want to sketch.

Keep it loose.

This is rule number one of sketching people in motion. The more you close your lines, the stiffer the people in the sketch will look. Loose strokes vibrate with motion. Don't overwork them. Just make sure the shapes match human proportions.

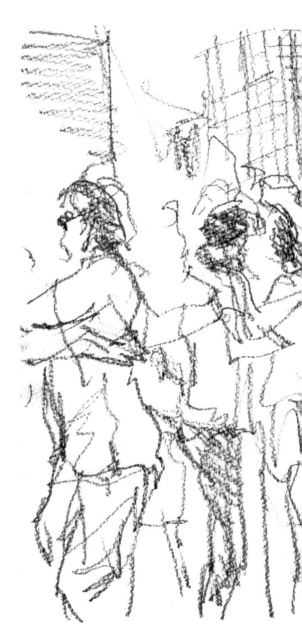

⊃ **KUMI MATSUKAWA**
Tango Lesson
9.3" x 7.5" | 24 x 19 cm; Pencil on Maruman Art spiral notebook; 10 minutes.

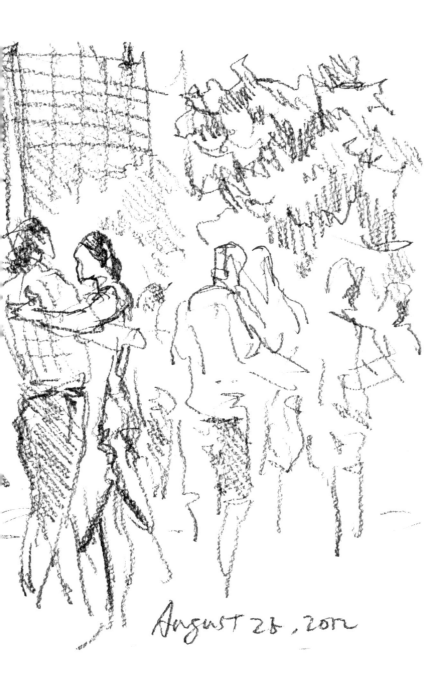

August 28, 2012

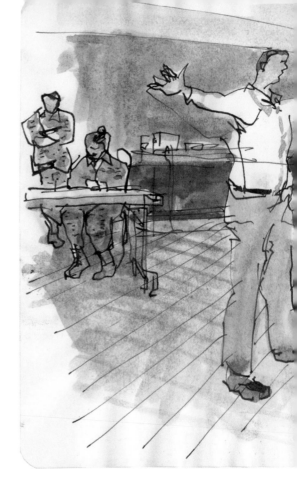

Freeze the moment.

If it happens in a split of a second, how is it even
possible to draw it? I like to take as much time as
I can just watching until I can spot the move that
I want to capture. The person going through this
checkpoint stood there for only a few seconds, but
more people came later and adopted the same
position, so the result is actually a composite of
many of the people who went through security.

⮑ I watched several free
throws at my son's basketball
game until I "saw" the pose I
wanted to sketch.

*5" x 7" | 13 x 18 cm; Pilot G-Tec
pen on mini Moleskine sketchbook;
10 minutes.*

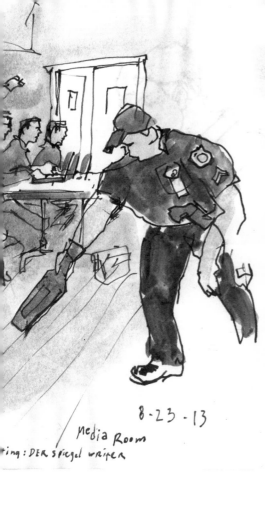

⊂ Watch for the position you want to sketch, and wait until the person repeats it several times. Memorize the pose and then sketch it.

7" x 5.5" | 18 x 14 cm; Ink and watercolor on Moleskine sketchbook; 15 minutes.

8-23-13

Media Room

ing: DER Spiegel writer

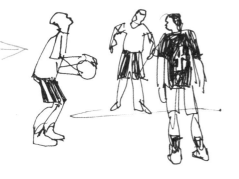

Memorize the pose.

When sketching a group of dancers, the trick is
to observe each move closely and memorize
poses, then draw them resorting to your previously
acquired knowledge of how the body works.

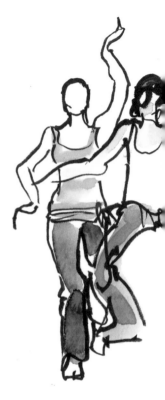

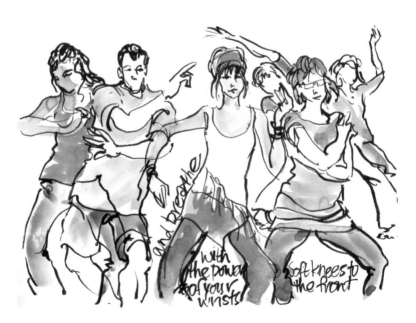

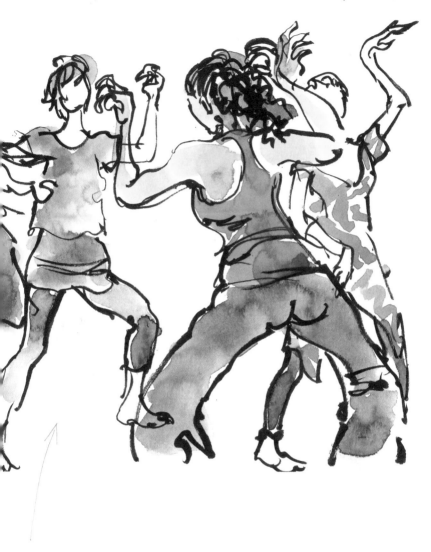

Some of these dancers are composites of several people. Sketcher Cathy Gatland would draw someone's torso and arms first, for example, and then add somebody else's legs to complete the figure.

CATHY GATLAND

Dancing Jam

10.3" x 7.3" | 26 x 19 cm; Brush pen and watercolor on sketchbook; 20 minutes.

Follow the leader.

An effective way to represent a person in motion
is to repeat the sketch of that person to create a
sequence. Draw the same person several times, in
different poses, and the idea of action comes across.

➲ Use motion lines around
limbs to emphasize action.

STÉPHANE KARDOS

*3" x 5" | 8 x 13 cm (each); Pilot
pen on Moleskine sketchbook;
about 5 minutes each.*

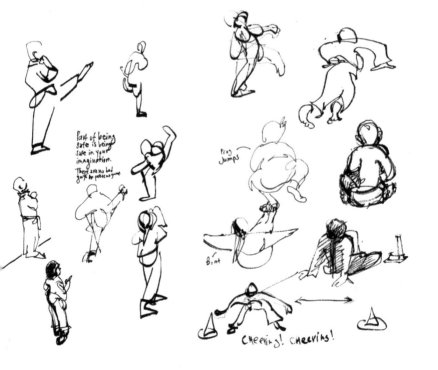

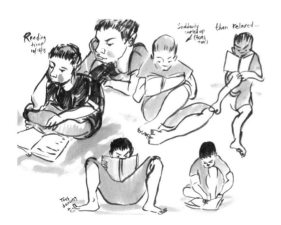

Workshop

Practice sketching kids
at play or doing an
activity as shown in these
sketches.

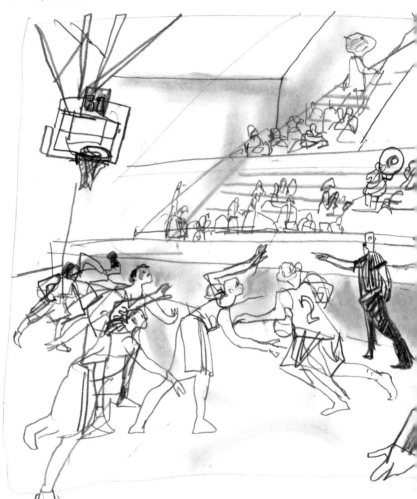

Add emphasis.

Action sketches benefit from a bit of exaggeration.
If you've been to a basketball game, you know
how those players can look as if they have three
or four arms. Longer limbs and legs in the sketch,
even if not totally accurate, help communicate your
perception of the game, as happens with this sketch
by New York artist Veronica Lawlor.

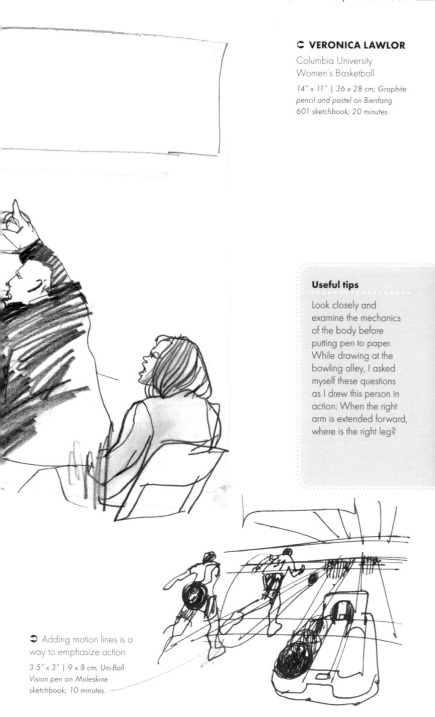

☯ VERONICA LAWLOR
Columbia University
Women's Basketball

*14" x 11" | 36 x 28 cm; Graphite
pencil and pastel on Bienfang
601 sketchbook; 20 minutes.*

Useful tips

Look closely and
examine the mechanics
of the body before
putting pen to paper.
While drawing at the
bowling alley, I asked
myself these questions
as I drew this person in
action: When the right
arm is extended forward,
where is the right leg?

➲ Adding motion lines is a
way to emphasize action.

*3.5" x 3" | 9 x 8 cm; Uni-Ball
Vision pen on Moleskine
sketchbook; 10 minutes.*

Use pencil to lock the pose.

This is a common technique among sketchers, and
I use it every now and then. Make light marks of
pencil to mark the posture you are aiming to draw.
It's a good approach when you really need to nail a
specific pose, such as the moves of dancers, athletes,
performers, or these graffiti artists, for example.

➲ Be careful not to over-
work the sketch when you
add ink over pencil lines.
The result may be too stiff.

Graffiti artists

*8.3" x 9" | 21 x 23 cm; Pencil,
ink, watercolor, and colored
pencil on Canson Mixed Media
sketchbook; 20 minutes.*

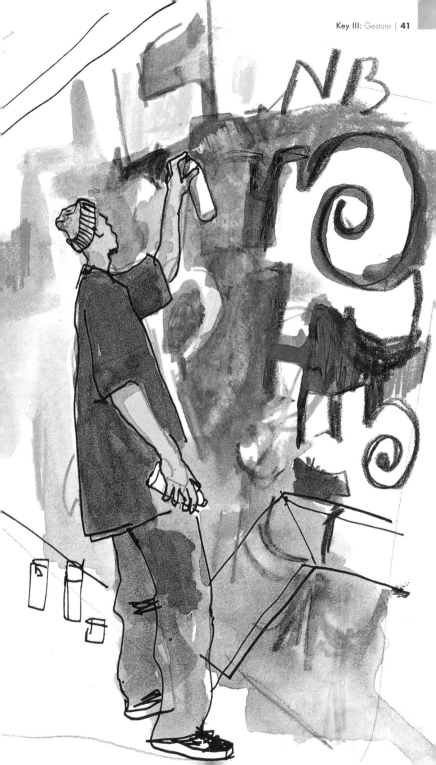

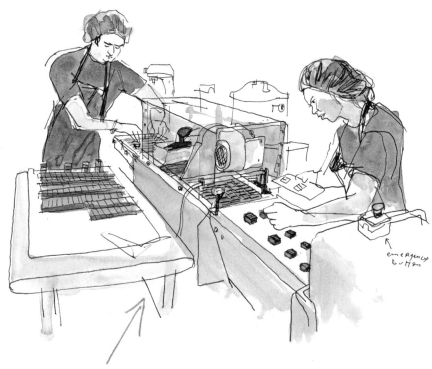

emergency button

⊙ Don't worry about making too many marks—reinstate the pose at any time and use watercolor to emphasize the move.

11" x 8" | 28 x 20 cm; Ink and watercolor on Canson spiral bound sketchbook; about 25 minutes.

Watch for repetitive steps.

Sketching people at work is a good way to sharpen your observational skills. People on the job tend to make repetitive moves, so don't worry if you miss the moment, as they are likely to come back to the same position.

Workshop

Practice this three-step process as you draw someone doing a repetitive task like the pizzaioli you see in my sketch.

1. Draw loose pencil lines to set the gesture.

2. Add watercolor to create shapes and volume. No need to erase the pencil!

3. Touch up with ink to emphasize parts of the sketch.

↻ Making New York-style pizza

11.4" x 8" | 29 x 20 cm; Pencil, watercolor, and ink on Fabriano Hot Press watercolor paper; about 30 minutes.

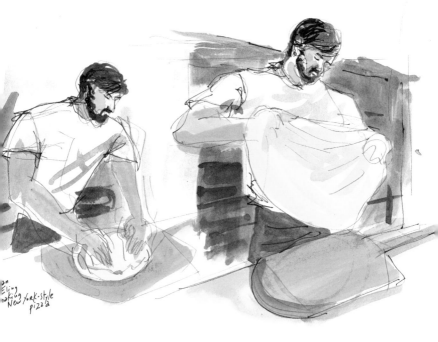

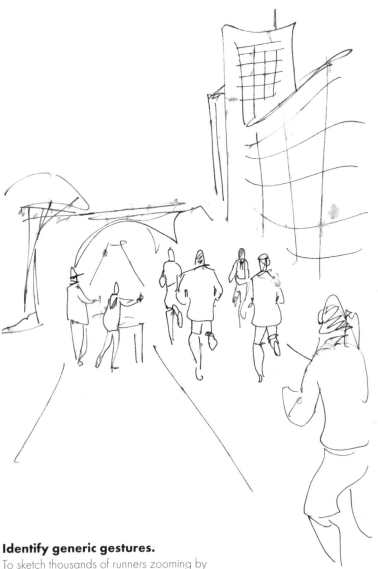

Identify generic gestures.

To sketch thousands of runners zooming by consider Julia Bolkachova's advice: All runners make more or less the same moves, so it's like sketching the same person passing by again and again. In these cases, you can make composites of several runners into one.

∩ ⊃ JULIA BOLKACHOVA

Montreal Marathon

*6" x 8" | 15 x 20 cm (each);
OptiFlow rollerball pen with
water-soluble ink; 30 seconds for
each sketch.*

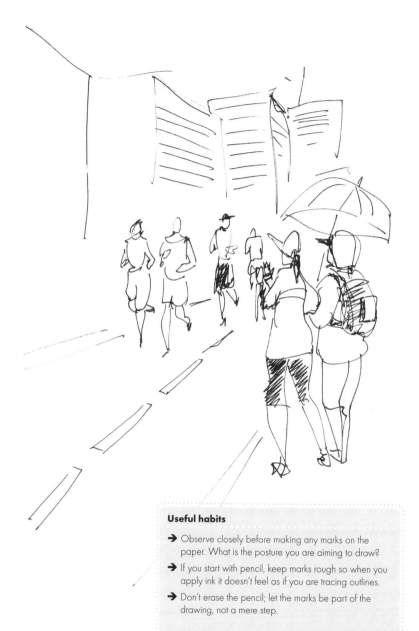

Useful habits

→ Observe closely before making any marks on the paper. What is the posture you are aiming to draw?

→ If you start with pencil, keep marks rough so when you apply ink it doesn't feel as if you are tracing outlines.

→ Don't erase the pencil; let the marks be part of the drawing, not a mere step.

SKETCH HERE!

KEY IV
EXPRESSION

Proportions and understanding of anatomy: check. Sharp memory skills: check. Now it's time to bring emotion to your drawings of people.

People have blood running through their veins. Their whole bodies, not just their faces, express their personality.

To draw them, try to feel how they feel. I find myself frowning when I draw someone who is tense, hurried if I'm drawing a rush-hour scene, or relaxed if I'm drawing people chilling at the coffee shop. To draw a busker playing the saxophone on the street, I let the music get under my skin.

Channel the feeling.

Internalizing the emotions of your subjects will make your sketches of people livelier and full of expression. Is the person you're drawing alert, relaxed, cheerful, or concentrating?

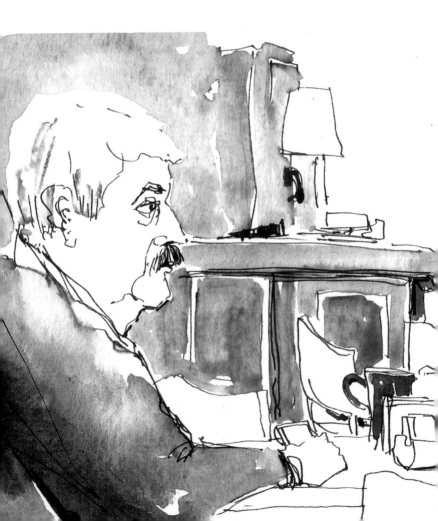

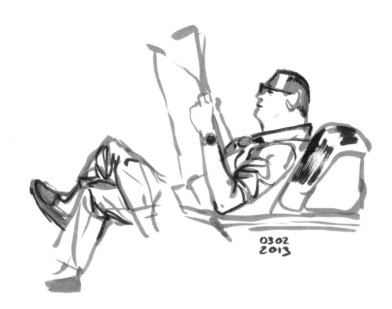

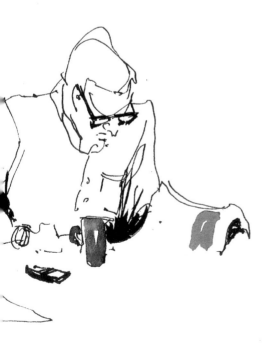

⌒ **STÉPHANE KARDOS**

13" x 9" | 33 x 23 cm; Tombow
and Pentel brush pens on Seawhite
of Brighton sketchbook; about
15 minutes.

⌒ **NORBERTO DORANTES**

8" x 5" | 20 x 13 cm; Art Pen and
watercolor; about 20 minutes.

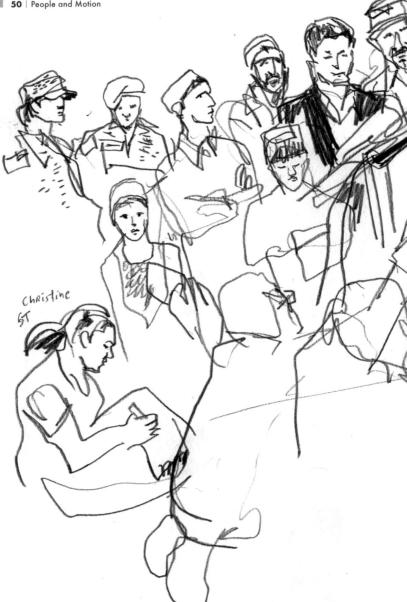

Christine
GT

🎧 Sketching at a press
conference

*11" x 14" | 28 x 36 cm; Pencil
on Fabriano Hot Press watercolor
paper; 15 minutes.*

Listen to capture the mood.

Performers are as fun to listen to as they are to
watch. Look at their expressions and movement,
and, most important of all, listen and let the flow
of their music carry into your linework.

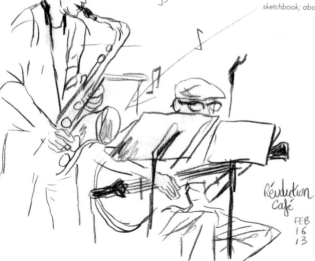

8 2313

❛ Don't feel the need to close the lines. Keep them open to suggest vibrancy.

STÉPHANE KARDOS

7.4" x 7" | 19 x 18 cm; Pencil on sketchbook; about 15 minutes.

Révolution Café
FEB 16 13

Pay attention to the body language.

Expression isn't confined to facial features.
Personality comes through in the way people
stand, walk, bend, or turn.

Useful habits

→ Eyes and mouth show
emotion. Watch the
way people stare,
frown, grin, and smile.

→ Observe body posture:
Is the head tilted down,
forward?

→ Soft lines convey
calmness. Bold marks
convey energy.

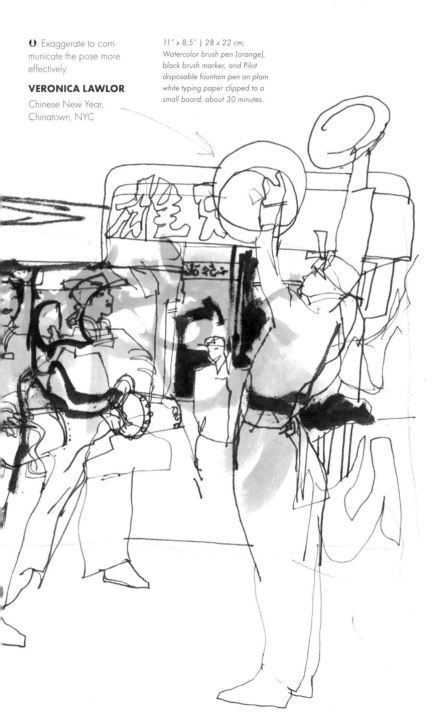

↻ Exaggerate to communicate the pose more effectively.

VERONICA LAWLOR
Chinese New Year, Chinatown, NYC

11″ x 8.5″ | 28 x 22 cm; Watercolor brush pen (orange), black brush marker, and Pilot disposable fountain pen on plain white typing paper clipped to a small board; about 30 minutes.

SKETCH HERE!

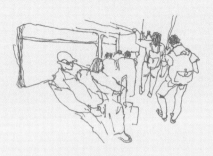

KEY V
CONTEXT

Proportion, contours, gesture, and expression are important notions to know when sketching people. But let's not forget this is a handbook on urban sketching. Our goal is to represent life in the context of the urban environment. That is, riding trains, walking through the park, or relaxing with a book at the neighborhood café.

A hint of the environment is enough to turn an isolated portrait into a true scene that captures a moment in time. Even if you are focusing on the subway commuter sitting across from you or the musician playing on the street, adding elements such as windows, the city skyline, or a lamp post will make the sketch more complete. It will be a truer representation of what you saw.

Suggest a background.

Keep your focus on the person you are sketching and then add a few background elements to set the scene. Be mindful that the more detail you add to the background, the less attention you'll draw to your subject.

⊃ I included a few bar stools and simple outlines of the cars, buildings, and trees I could see through the window while sketching my son at our favorite pizza place.

3" x 5" | 8 x 13 cm; Uni-Ball Vision on Moleskine sketchbook; 10 minutes.

↺ JERRY WAESE

Bloor Street Busker

11" x 8" | 28 x 20 cm; Ink pen, red China marker, and Neocolor crayons; 15 minutes.

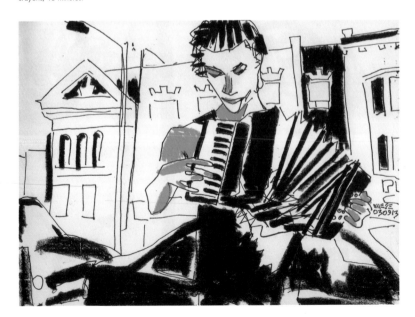

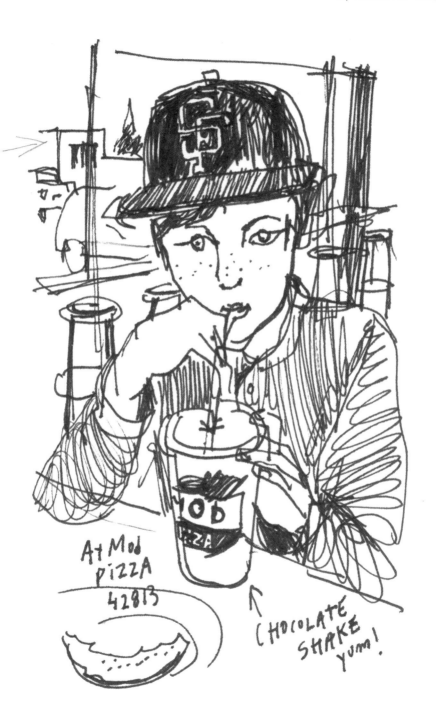

At Mod
Pizza
42813

← (CHOCOLATE
SHAKE
Yum!

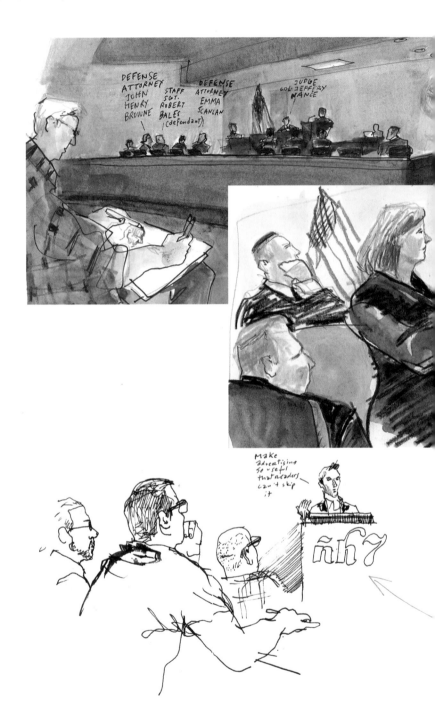

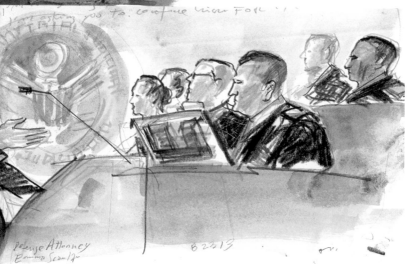

🎧 Courtroom trial

14" x 5" | 36 x 13 cm (each sketch); Pencils of various grade (H, 2B, and 6B), watercolor, and ink on Fabriano Hot Press watercolor paper; about 40 minutes.

🎧 In this sketch, I moved the lectern closer to the audience in order to get a certain likeness of the speaker.

7" x 5.5" | 18 x 14 cm; Fountain pen on Moleskine sketchbook; 15 minutes.

Compress the scene.

Drawing people in spaces such as lecture halls or courtrooms presents a compositional challenge. The subjects usually stand too far apart from each other. To focus on the characters (bottom sketch), you have to sacrifice actual spacial relationships (top sketch). In those cases, I take artistic license by moving people and furniture elements closer to each other to tighten up the space.

Superimpose "ghost" people.

Here's a way to suggest motion and activity: Overlap silhouettes of people marching through the space. Don't be afraid of adding people over previously drawn benches, fountains, or buildings.

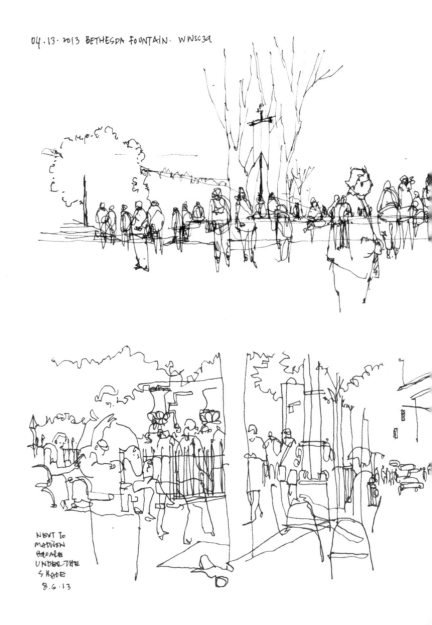

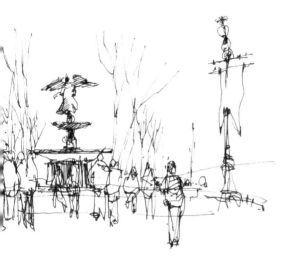

☮ RICHARD ALOMAR

Bethesda Fountain,
Central Park

*6" x 15" | 15 x 38 cm; Lamy
Safari fountain pen (fine tip) and
Noodler's ink on 90 lb cream
Stonehenge Paper; 20 minutes.*

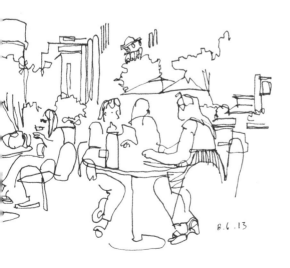

☮ CAROL HSIUNG

Lunch at Madison

*12" x 4" | 30.5 x 10 cm; Micron
01 black pen on sketchbook;
30 minutes.*

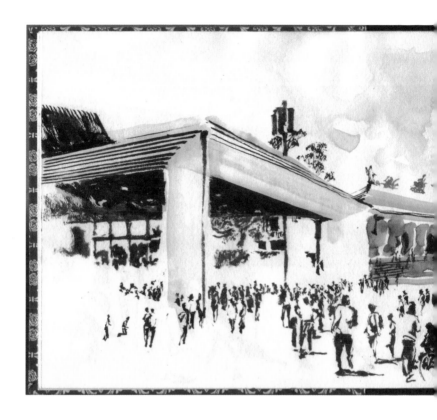

∩ **JOÃO CATARINO**

Fatima, Portugal

17" x 7" | 43 x 18 cm; Pentel brush pen and watercolor on sketchbook; 1 hour.

Use people to emphasize scale.

People create a sense of scale in the scene. The expansive space, like the one João Catarino drew on this spread, is grasped thanks to the small marks that represent the crowd.

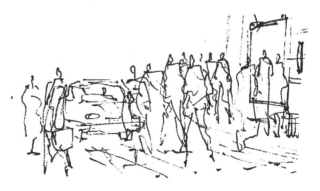

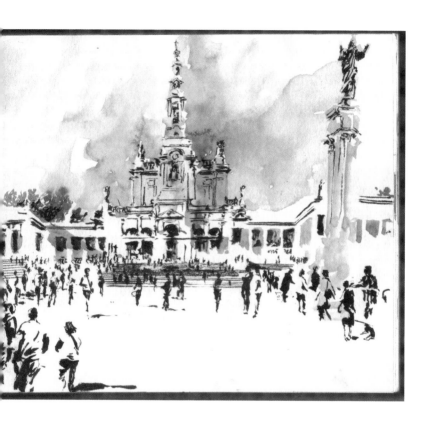

Useful habits

Experiment with simple line marks to suggest pedestrians on the street. These types of "bubble people," as an architect friend of mine refers to them, are generic enough that you can use them to respond to any sketching situation.

On the sketch, handwritten: *Paris · Hôtel de Ville · Sitting on the Curb on Traffic Island · I pass this amazing building all the time to the art G. 25 July 2013 · S.Bower*

⋒ STEPHANIE BOWER

Hôtel de Ville, Paris

5" x 16" | 13 x 41 cm; Mechanical pencil and watercolor on Pentalic 5" x 8" (13 x 20 cm) watercolor sketchbook; about 90 minutes.

➲ Heads align with your eye level, also known as the horizon line, when you and your subjects are standing on the same plane. I keep this in mind every time I sketch groups of people. Note that because some people are taller than others, their heads may be slightly above or below the horizon line.

7" x 7" | 18 x 18 cm; Fountain pen and watercolor on 7" x 10" (18 x 25.5 cm) Canson Mixed Media sketchbook; 10 minutes.

Watch people's heads.

At first glance, the sketches you see here don't seem to have anything in common. But look closely at the people. Their heads are all placed at about the same height on the page. That means everyone is standing on the same plane as the sketcher.

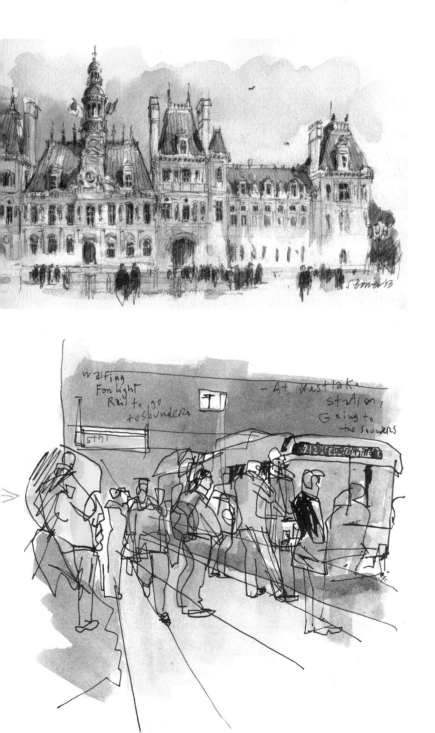

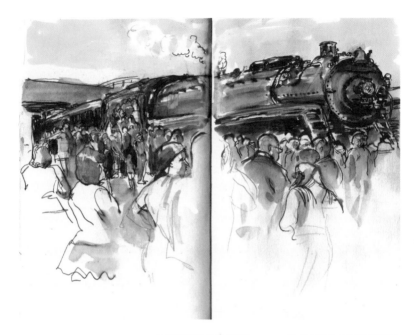

∩ KALINA WILSON

11" x 8.5" | 28 x 22 cm; Pencil, Daniel Smith watercolors, J. Herbin Bleu Azur ink in a Kuretake brush pen; Noodler's Konrad fountain pen with Noodler's Bulletproof Black ink on Stillman & Birn Alpha sketchbook; about 30 minutes.

↻ SUHITA SHIRODKAR

Crowded Street, Mumbai, India

9" x 12" | 23 x 30.5 cm; Pen, ink, and watercolor on Stillman & Birn Beta sketchbook; about 1 hour.

Go from detail to suggestion when drawing crowds.

Crowds may feel intimidating to draw. So many people, right? But study sketches of crowds closely and you realize that only the people in the foreground need detail. The rest can be suggested with just a few strokes.

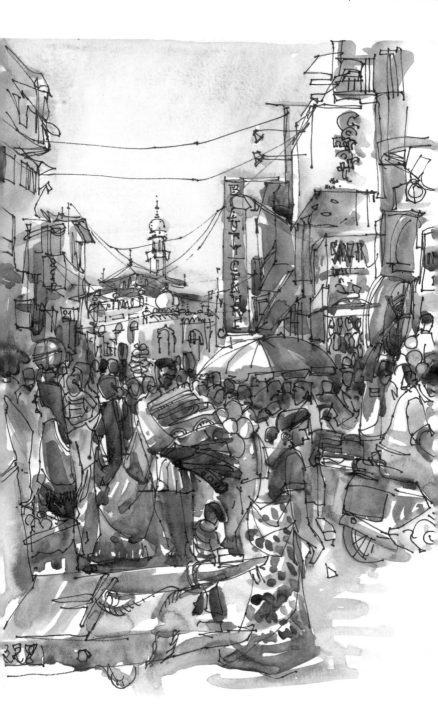

Think of the scene as a unit.

We tend to think of people and the environment
as two separate worlds, but in reality, everything is
part of one single scene. Draw them continuously,
going back and forth between background and
foreground for a cohesive sketch, such as in these
market scenes.

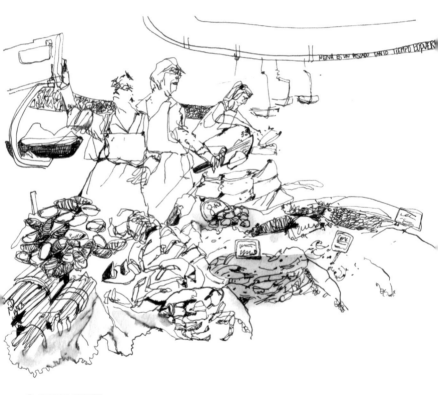

⌒ JESICA LEWIT

Fish market stand

*11" x 8" | 28 x 20 cm; Fountain
and dip pens, ink and watercolor
on paper; 45 minutes.*

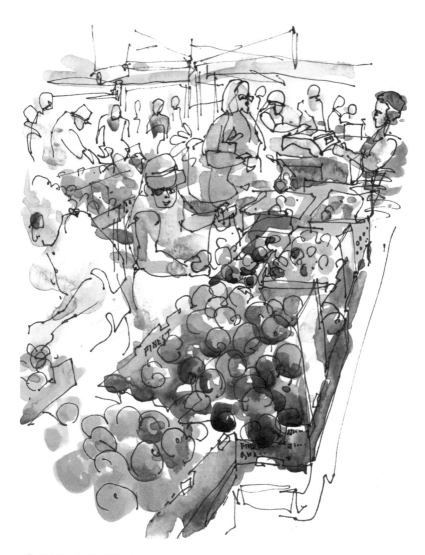

∩ **SUHITA SHIRODKAR**

Summer bounty at the
farmers' market

*7″ x 10″ | 18 x 25.5 cm; Extra
Fine Point Sharpie and watercolor
on Cachet watercolor sketchbook;
about 20 minutes.*

SKETCH HERE!

KEY VI
LIKENESS

How much do you need your sketches of people to look like the actual people you are drawing? Likeness is not needed when you are drawing crowds or pedestrians, and urban sketching isn't really about making people pose for you. People often become stiff and unnatural if they realize they are being portrayed.

But situations come up as you go urban sketching when you'll want to achieve a certain likeness. You may be sketching someone who is talking to you at close range. Or your subject may be so important to the story of the sketch, that you'll want to remember how the person really looked.

Draw without mercy.

Barcelona-based sketcher César Caballud offers up a good tip to draw portraits: You have to be merciless. In other words, don't try to make a flattering sketch. The line between capturing a portrait without mercy and creating a caricature can be blurry. If you don't have the intent of caricaturizing people, the result is bound to be a believable sketch.

◑ EMILY NUDD-MITCHELL

Maria, a Parisian and Catalan painter

8.25" x 11.75" | 21 x 30 cm; A5 sketchbook, ink gel Pilot pen (black, white, and gold), watercolors and watercolor pencils, paper collage; 30 minutes on location, 30 minutes coloring later.

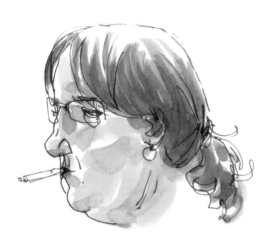

↻ CÉSAR CABALLUD

4.5″ x 4.5″ | 11.5 x 11.5 cm; Ink and watercolor; 5 minutes.

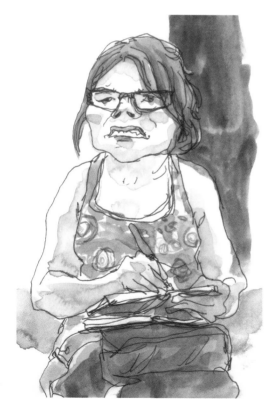

↻ CÉSAR CABALLUD

4″ x 6″ | 10 x 15 cm; Ink and watercolor; 20 minutes.

Tell a story.

As frustrating as sketching people may be at first, there's a big reward to staying the course. Sketching people can introduce you to some very interesting folks with great stories about themselves. Your sketches will gain a new storytelling dimension when you incorporate people into them.

◑ INMA SERRANO

Montse en la Corrala Utopía

10.5" x 8.3" | 27 x 21 cm; Watercolor, Uni Pin 0.2 pigment liner, water-soluble pencils on gray Strathmore paper; about 20 minutes.

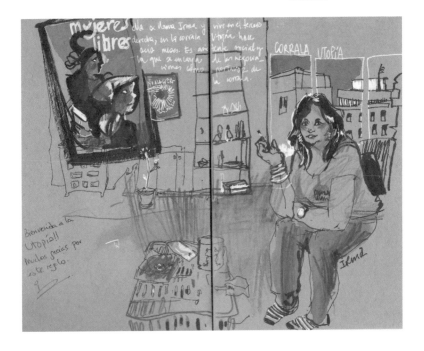

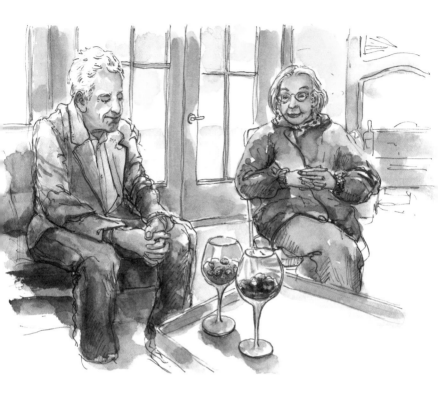

⌕ RICHARD SHEPPARD

Helen and Charles
Bacigalupi

*10" x 7" | 25.5 x 18 cm; Ink and
watercolor; drawn over the course
of 2 hours while interviewing.*

Useful habits

Watch the eyes and
mouths of your subjects.
Noses, ears, and
foreheads don't really
move. The gist of a facial
expression lies in the eyes
and mouth, so that's where
I pay the most attention.
I like to start drawing the
eyes first and work my
way out from the center of
the face to the shape of
the head.

SKETCH HERE!

GALLERY I
PENCIL

Pencil is especially suited for drawing people and motion because it responds to pressure. You can draw lines and shade very fast, building up the sketches from soft lines to darker strokes as you re-create your subjects on the page. The graphite glides over the paper and helps you sculpt shapes with its tonal versatility.

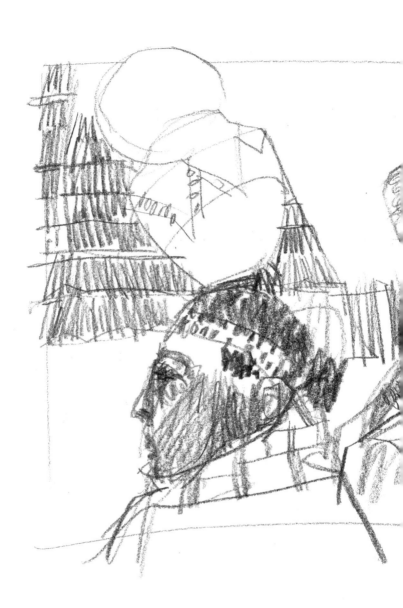

🎧 Kwazulu-Natal,
South Africa

11" x 8.5" | 28 x 22 cm; Ebony
graphite pencil on Strathmore
paper; 20 minutes.

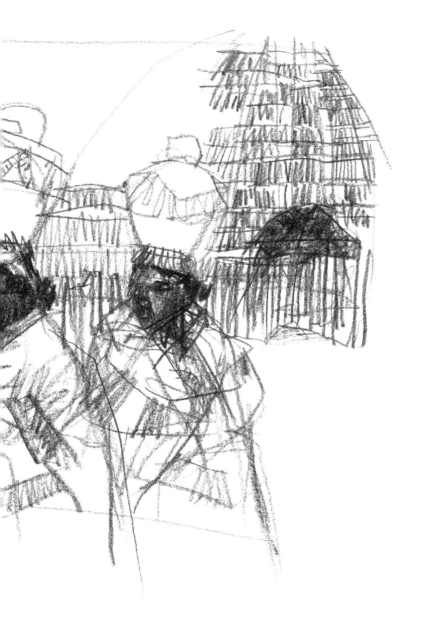

"A pencil glides over the page with an ease that allows a quick capture." —Melanie Reim

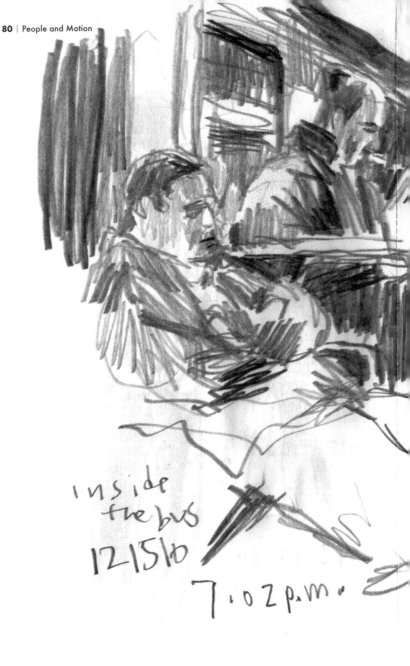

inside
the bus
12/15/0

7.02 p.m.

🎧 Bus Commuters
7" x 5.5" | 18 x 14 cm; 2B Pencil
on Moleskine notebook;
15 minutes.

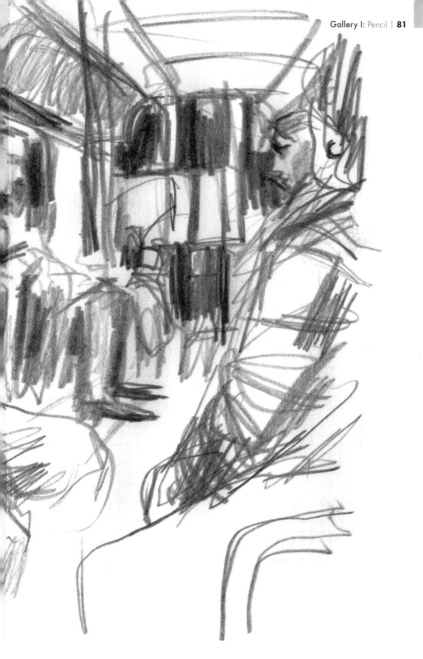

"I try to remind myself to take advantage of the qualities of pencil and not use it just to make lines. It's an ideal tool for shading, for sculpting a scene in dark contrasts." —Gabriel Campanario

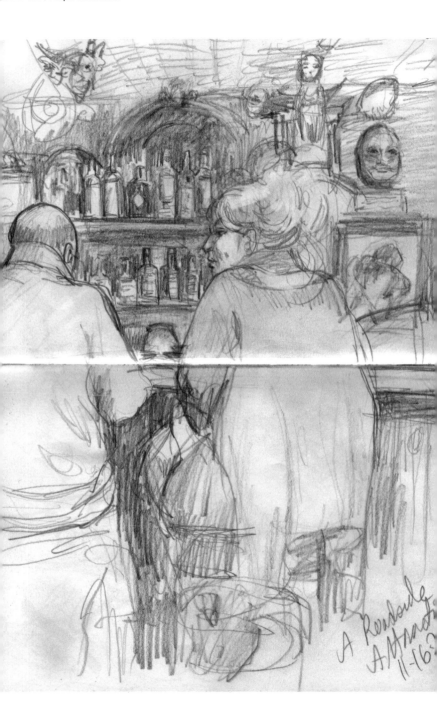

♫ Bar scene

8" x 10.5" | 20 x 27 cm;
Palomino Blackwing 602 pencil
on Canson ArtBook Universal
sketchbook; about 20 minutes.

"I tend to use pencil when the subject
matter is complex or dimly lit. With pencil,
it's easy to bring out shapes and figures as
you realize they are important, while other
traces get left behind, undeveloped."
—Kalina Wilson

SKETCH HERE!

GALLERY II
PEN AND INK

Straight-to-ink people sketching requires confidence, but the payoff is well worth the try. For one thing, you can produce many more sketches on the fly than if you had to sit down to add color. Impatient sketchers, like me, relish this method, and it's not only because it maximizes time: Quick ink marks tend to lead to expressive sketches, and that's a quality that can make a drawing stand out. If you use a ballpoint pen, lines flow easily onto the page, creating that sense of motion that makes a sketch lively and interesting to look at.

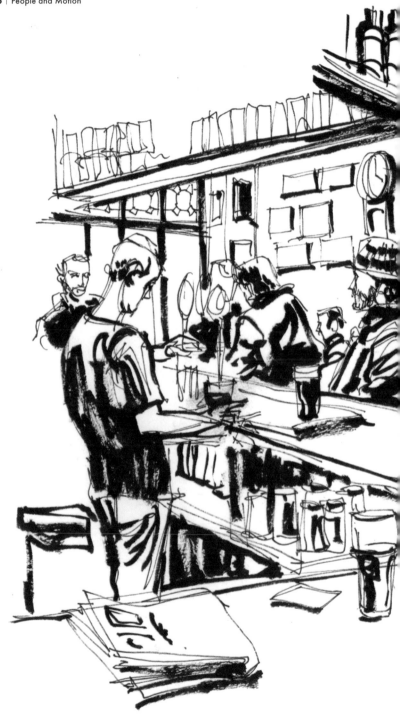

⊂ Tig Cóilí, Galway

5.5" x 8" | 14 x 20 cm; Staedtler Pigment liner 0.3 and Waterbrush filled with diluted black liquid acrylic ink on Canson A5 heavy cartridge sketchpad; 20 minutes.

"I fill brush pens with varying degrees of diluted liquid acrylic ink. Beware: They will clog up if you mix in too much ink; you've got to get the balance right."
—Roger O'Reilly

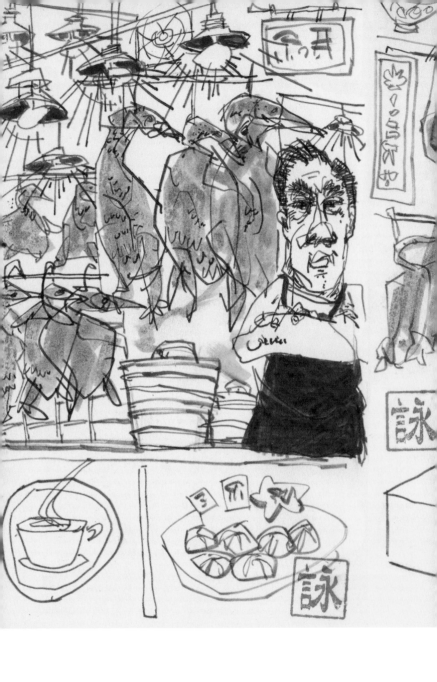

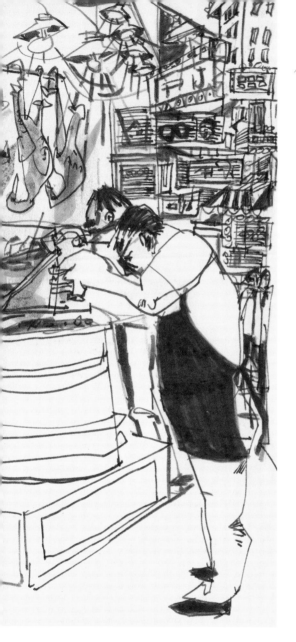

"I love being able to record body language, gesture, and expression to tell a story. My advice is to look for shapes along with movement and work with contrasts of weights and lengths of line—put it down fast and furious!"
—Melanie Reim

♈ The Language of Pride in Hong Kong

5" x 8" | 13 x 20 cm; Pelikan cartridge pen, Pentel brush pen (gray) on Moleskine sketchbook; 20 to 30 minutes.

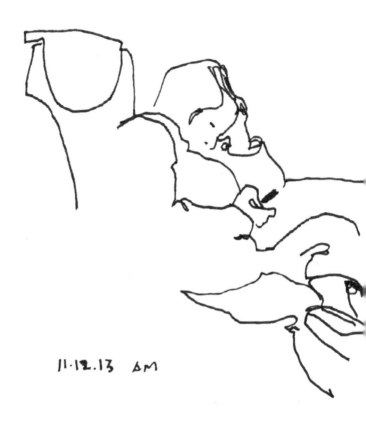

11·12·13 AM

∩ Slow Train

6" x 4" | 15 x 10 cm; Micron 01
black pen; 3 to 5 minutes.

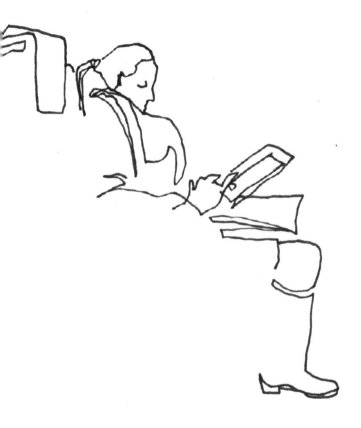

"'Drawing is taking a line for a walk' [Paul Klee] It's what my pen does with lines when I sketch people. I sketch thinking in composition using positive and negative space between the lines to connect people with environment. My pen goes on a journey to tell a story." —Carol Hsiung

SKETCH HERE!

GALLERY III
WATERCOLOR

The sketcher who relies exclusively on watercolor when sketching people deserves a tip of the hat. Even if you rely on a light pencil underdrawing, this is not an easy approach when you are aiming to complete sketches on location. However, the results can feel very free and spontaneous. Watercoloring on the go may not be a good fit for the fussy sketcher who wants to add a lot of detail, but it will delight those who value expressiveness over accuracy.

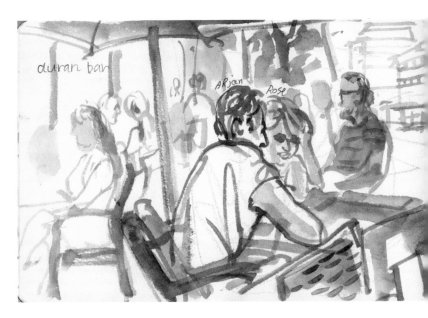

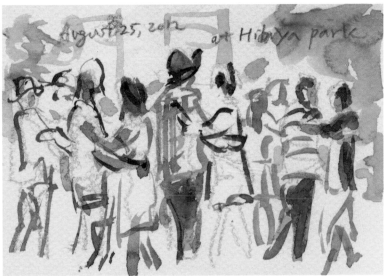

♬ Dancing Tango

*5.7" x 3.9" | 15 x 10 cm; Colored
pencil and watercolor on tinted
paper; 10 minutes.*

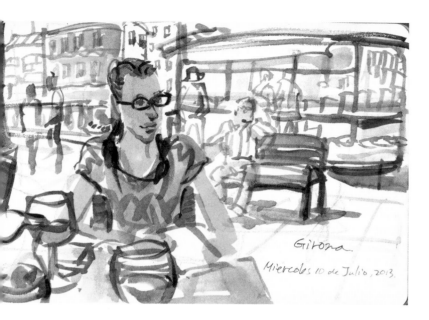

⌒ Duran bar

16.5" x 5.2" | 42 x 12.75 cm;
Colored pencil and watercolor on
Hahnemühle travel sketchbook;
1 hour.

"Capturing people in a live scene is difficult yet rewarding. It requires patience and agility. Their move is unpredictable. It is like surfing, when you capture the wave and ride on it for just a certain moment, you'll feel so good." —Kumi Matsukawa

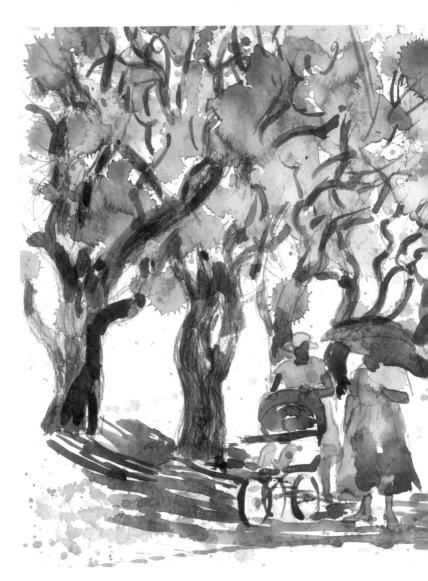

"I freely splashed the paper with the colors of the jacarandas, dropping and flicking with a loaded paintbrush, then sketched and painted the women as they approached with a few quick pencil lines and brushstrokes—adding the tree trunks and shadows after they'd passed by." —Cathy Gatland

◖ Joburg Jacarandas

12.6" x 9.3" | 32 x 24 cm;
Pencil and watercolor; 30 minutes.

SKETCH HERE!